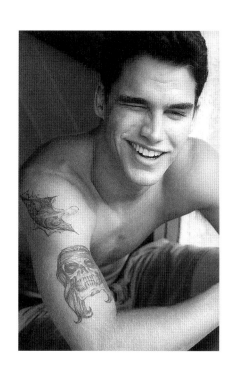

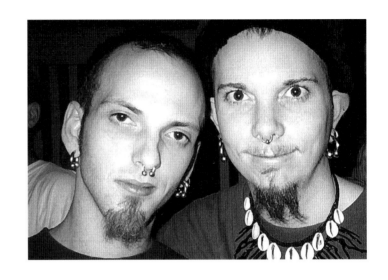

color full pain

Walter Kehr
tattoo piercing
universe

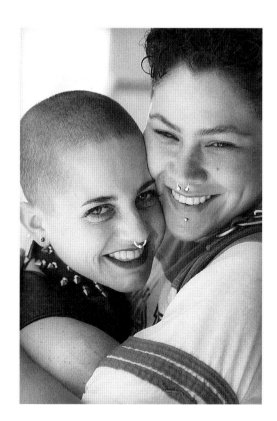

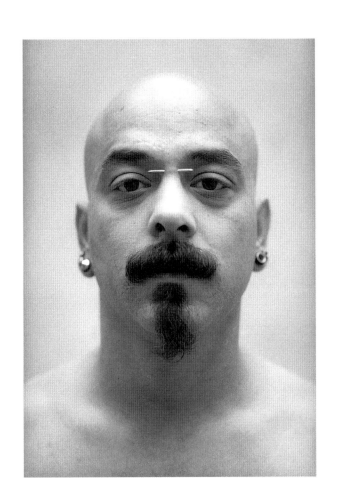

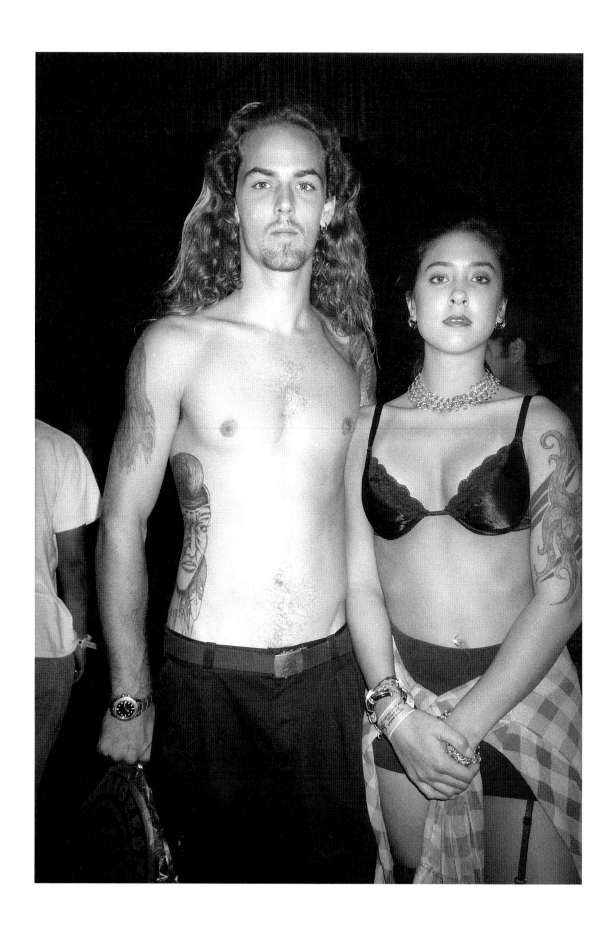

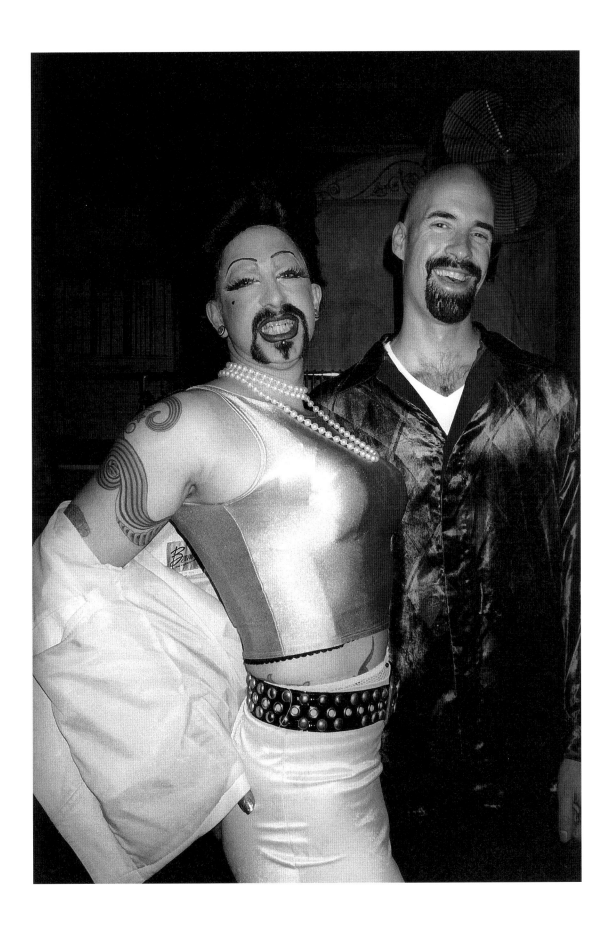

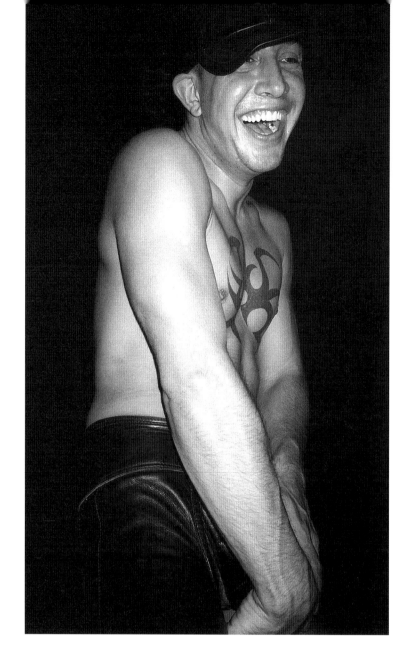

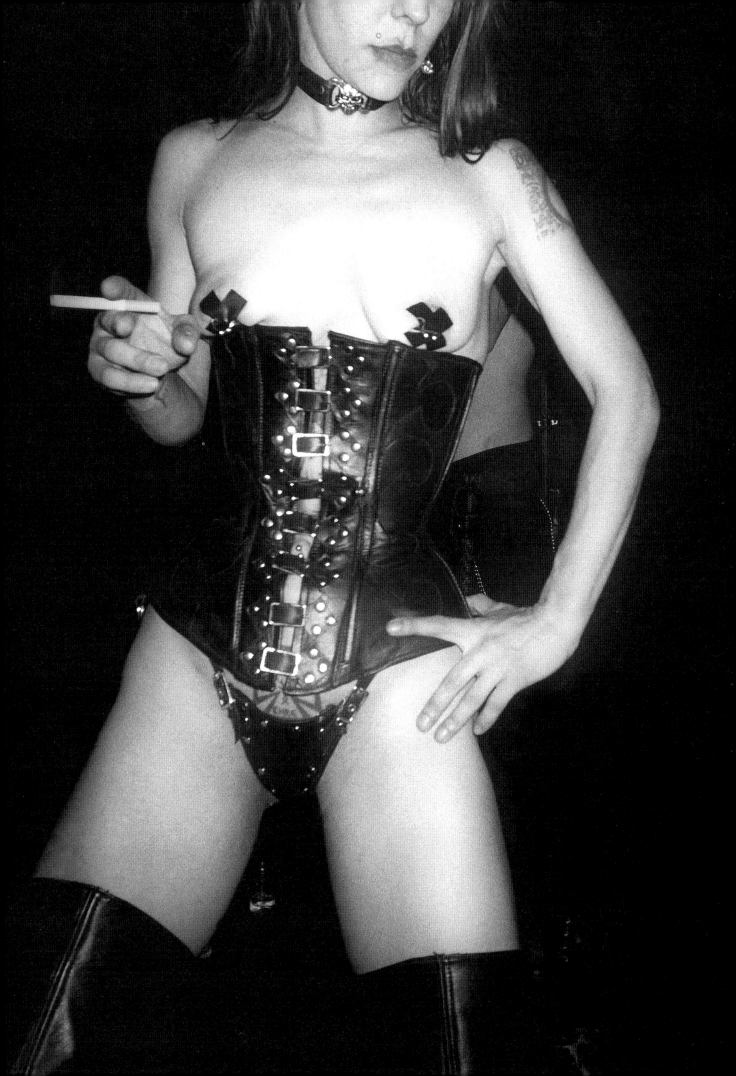

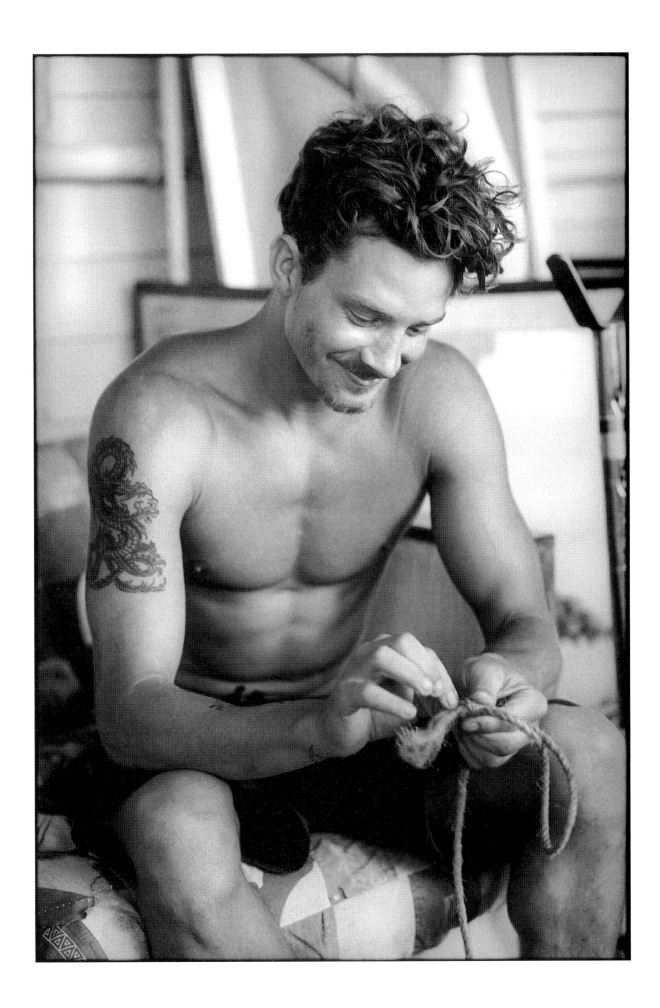

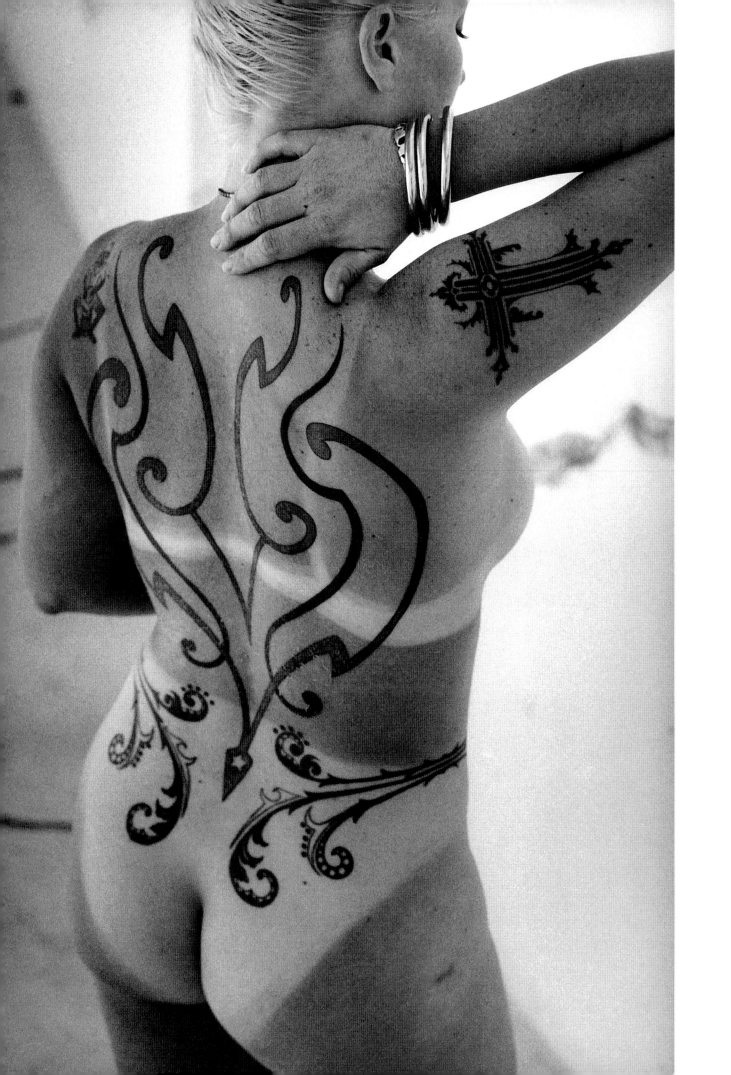

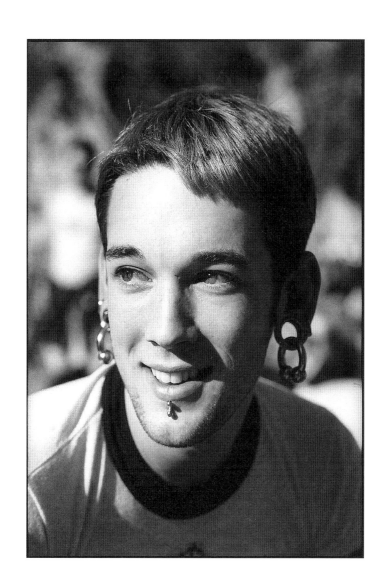

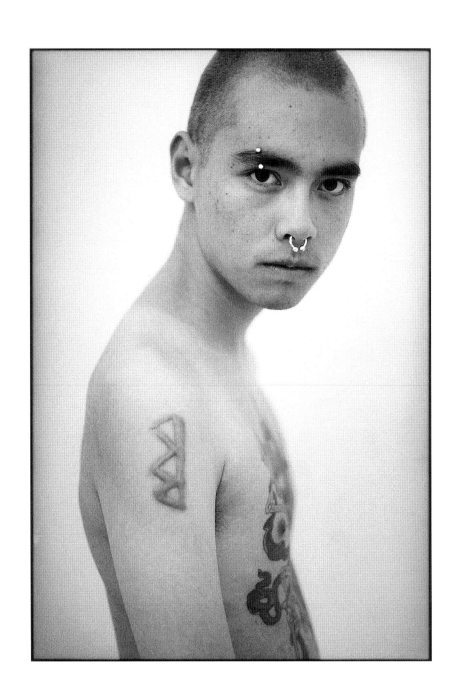

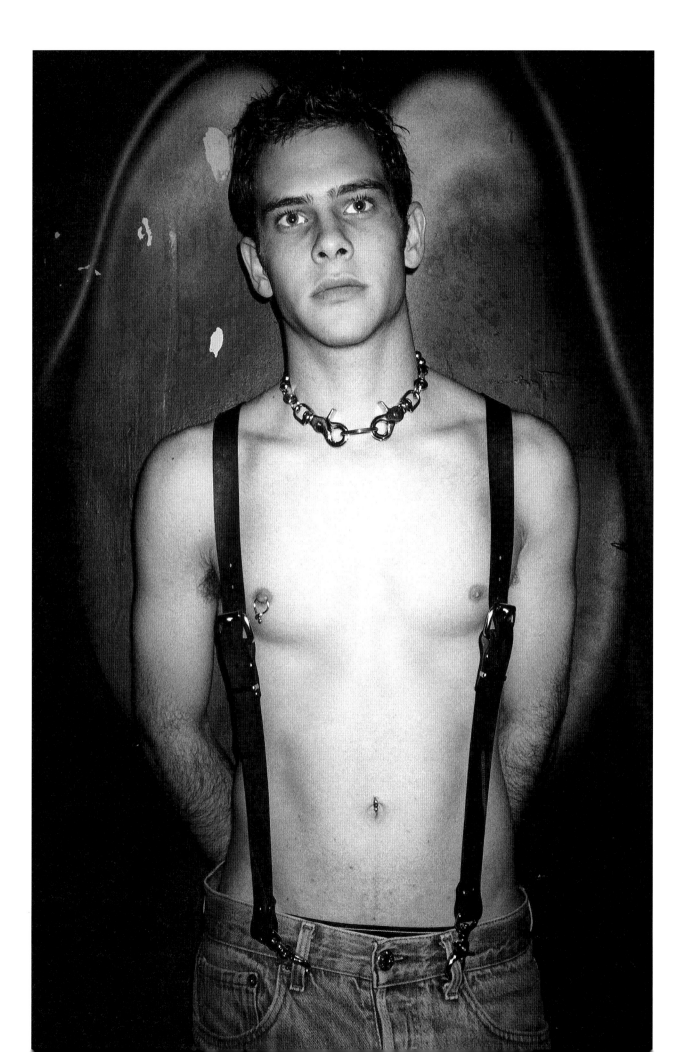

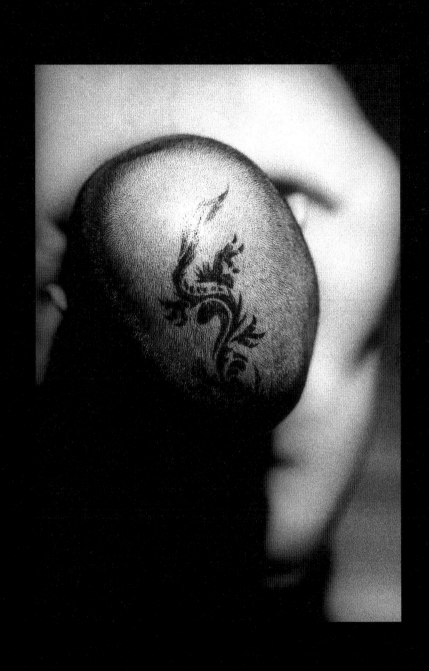

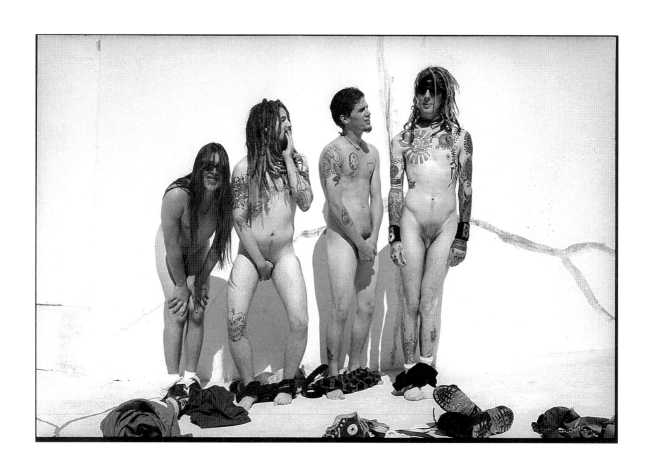

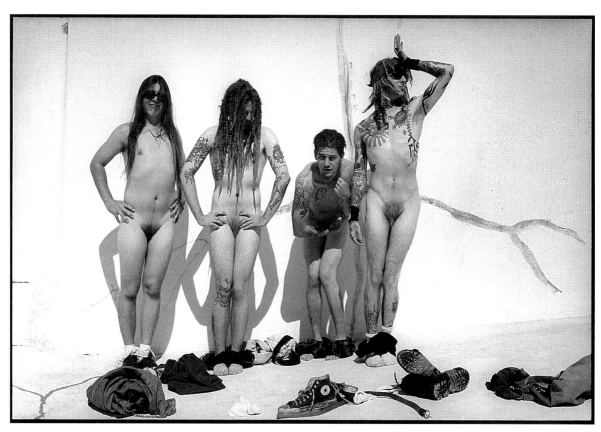

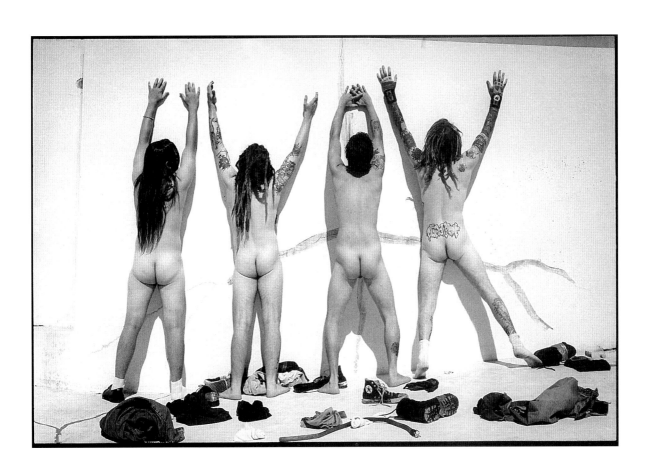

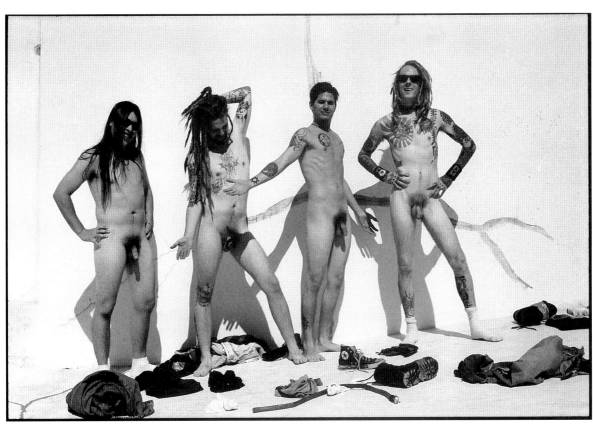

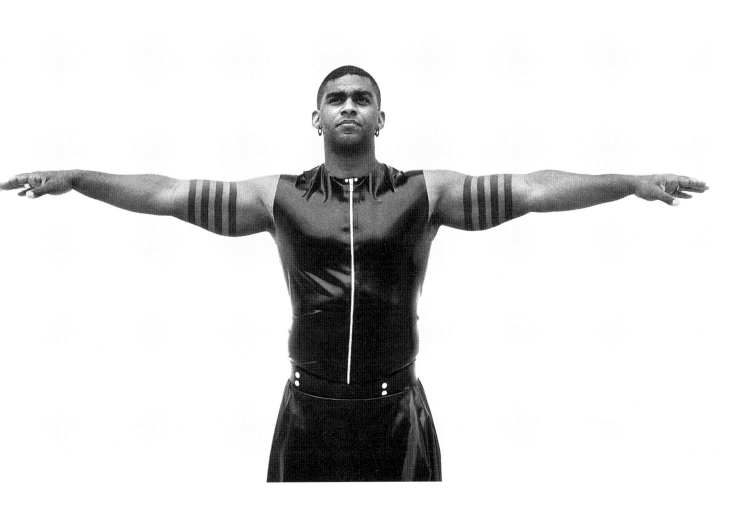

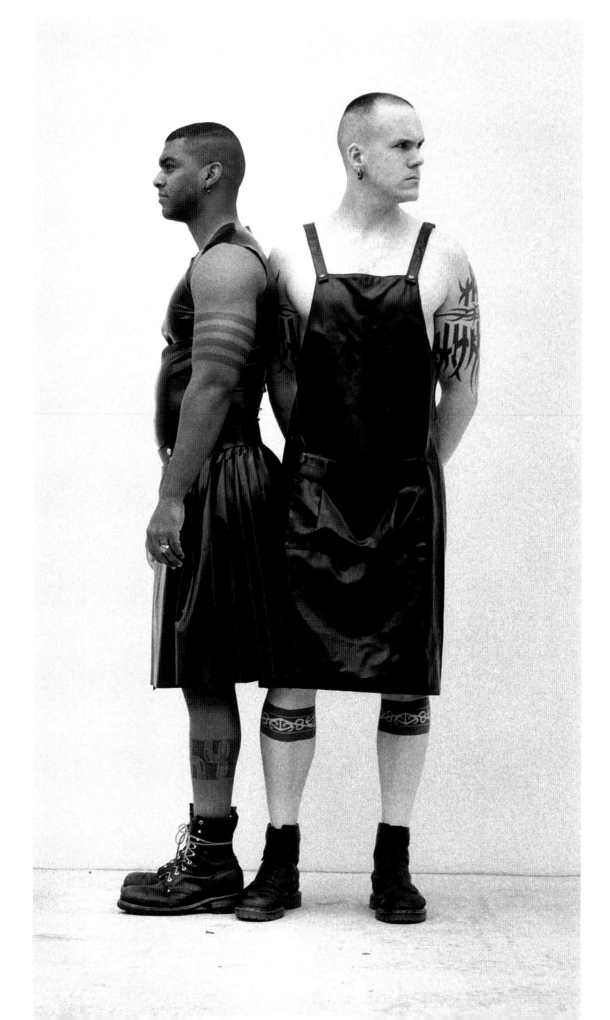

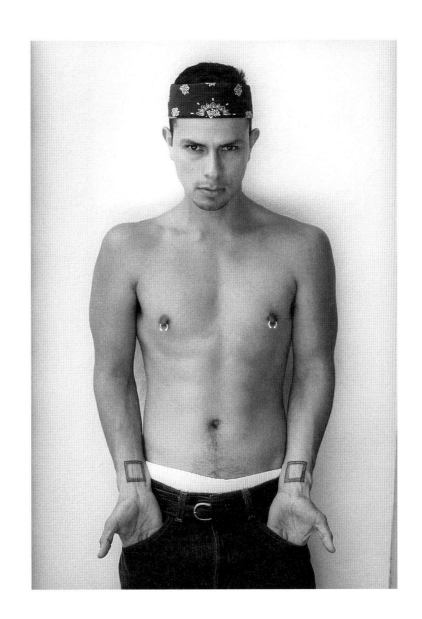

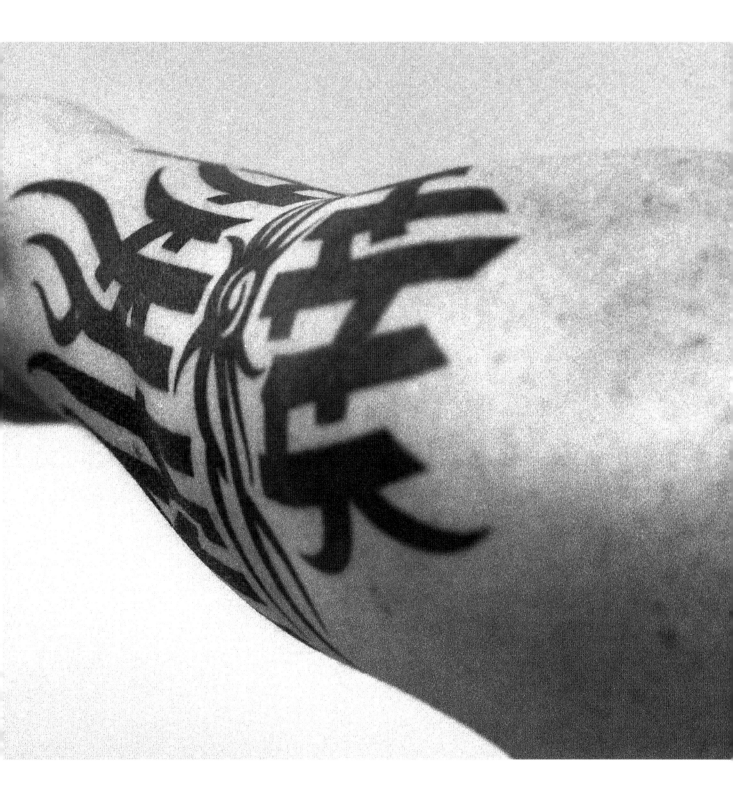

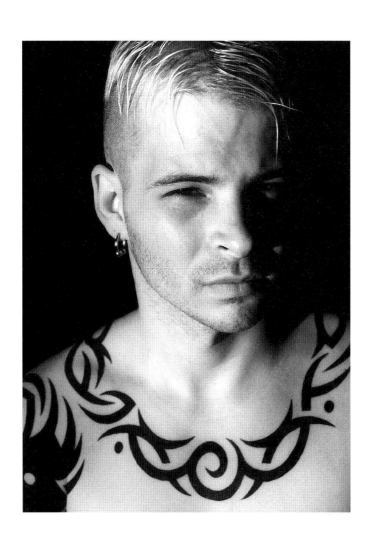

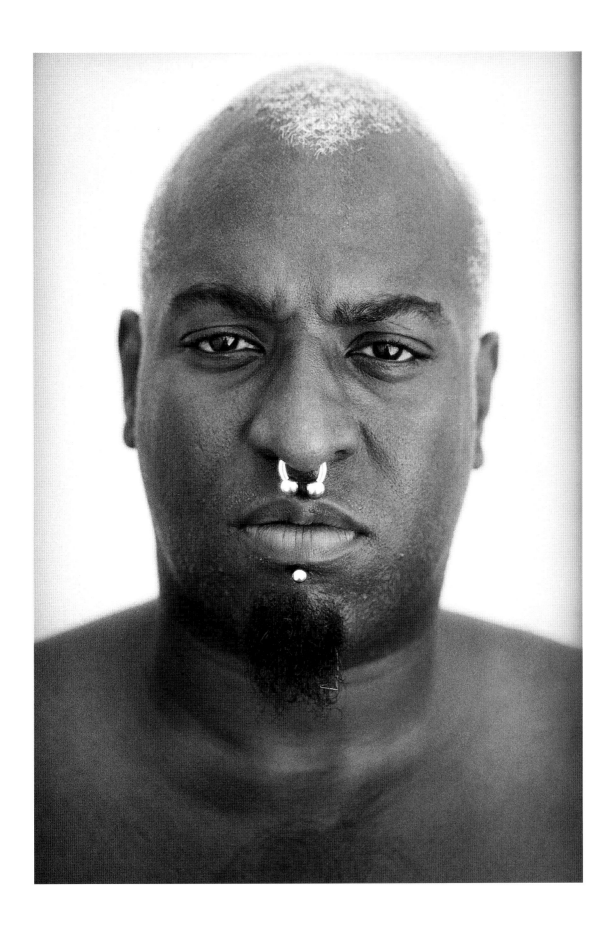

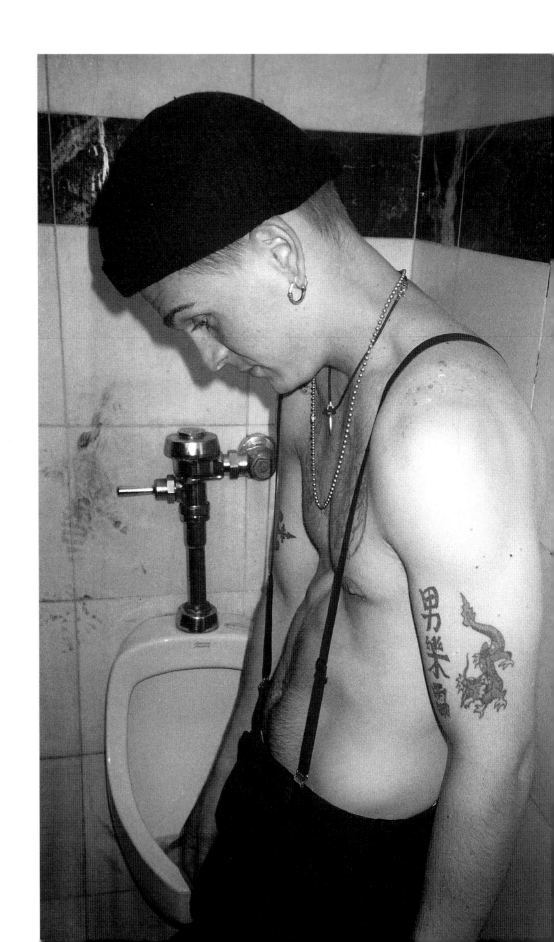

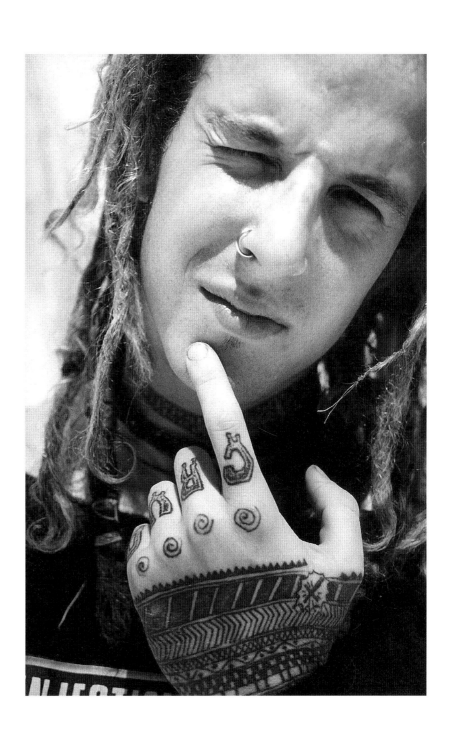

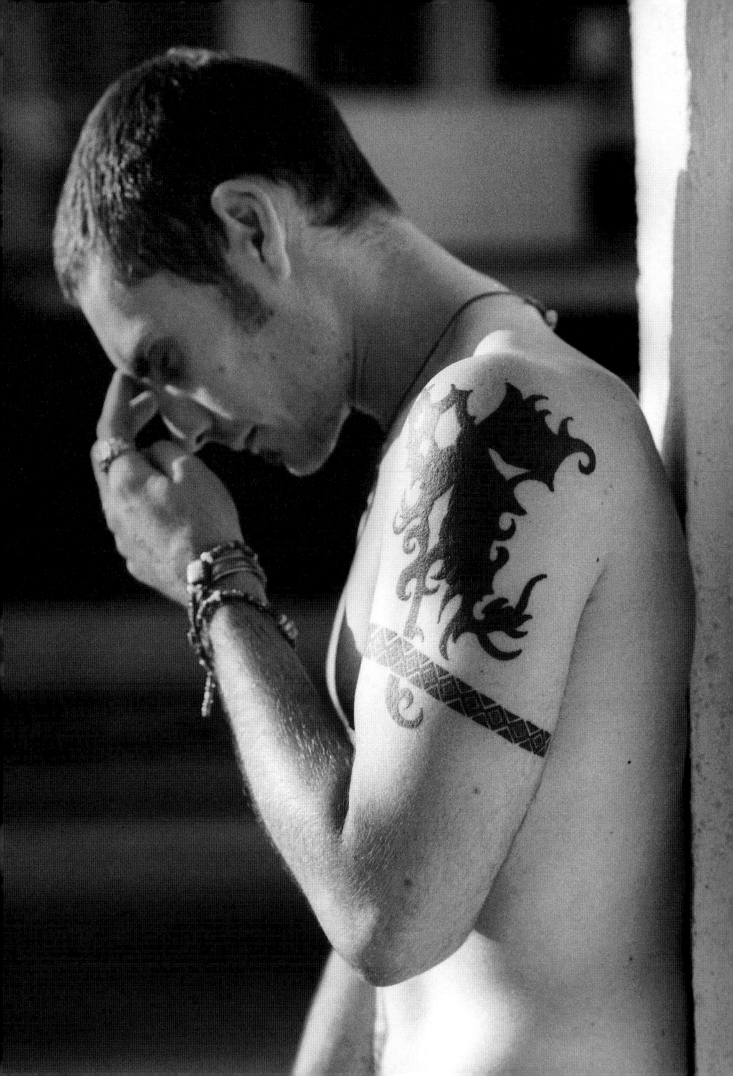

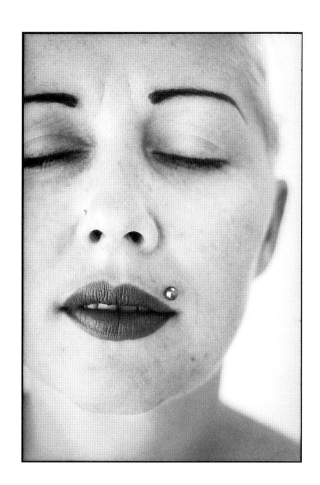

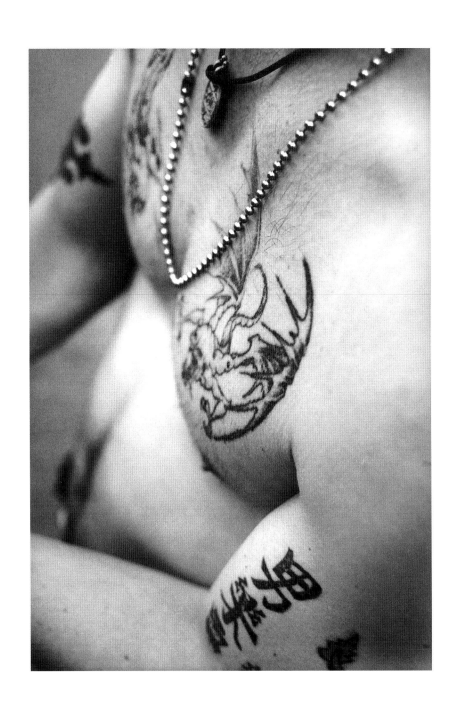

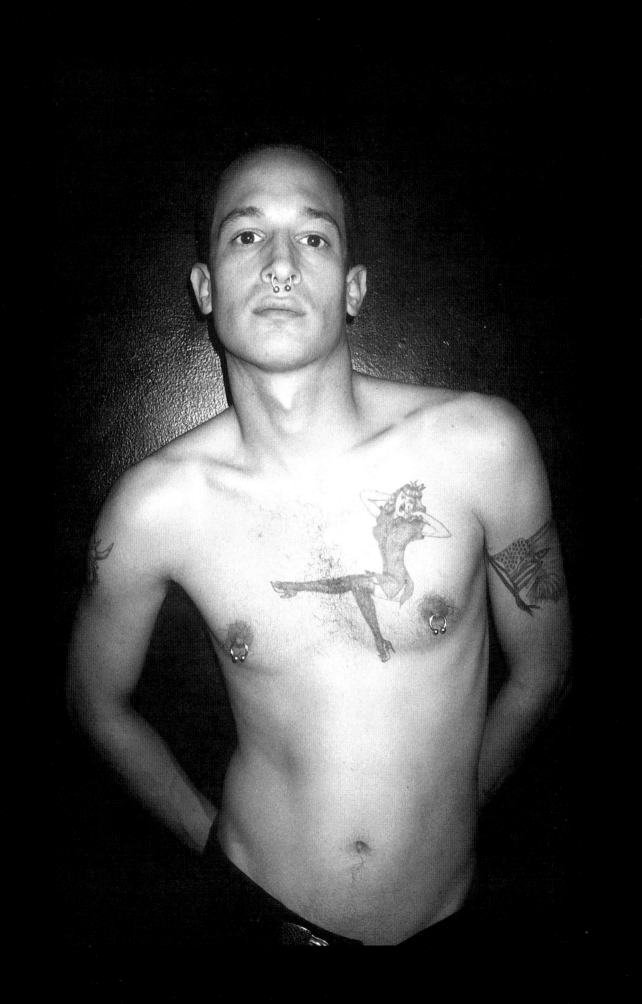

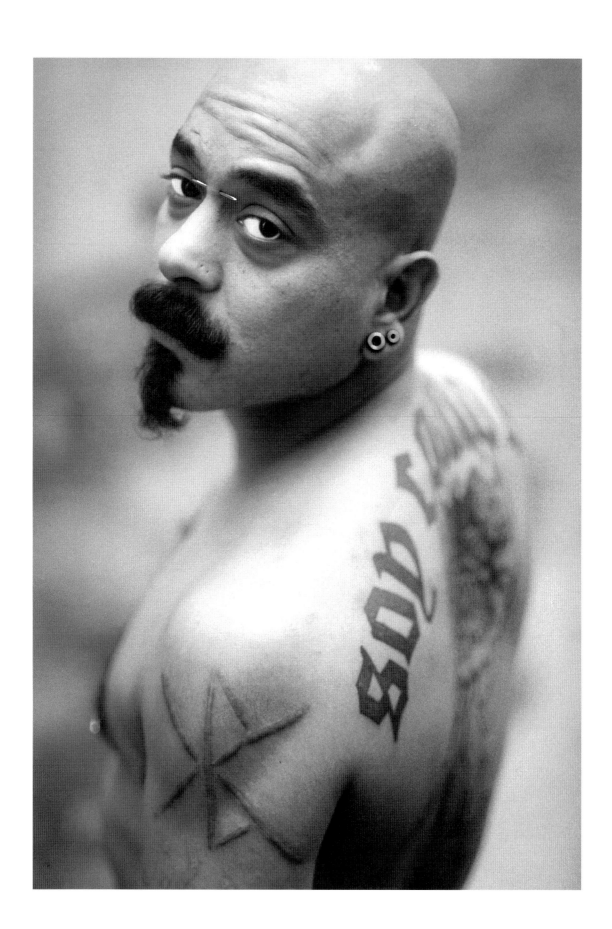

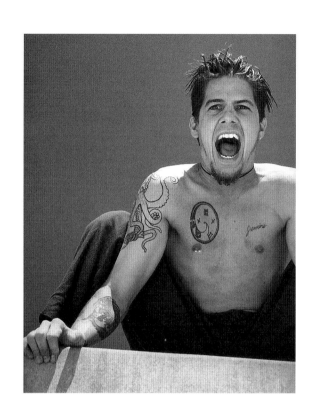

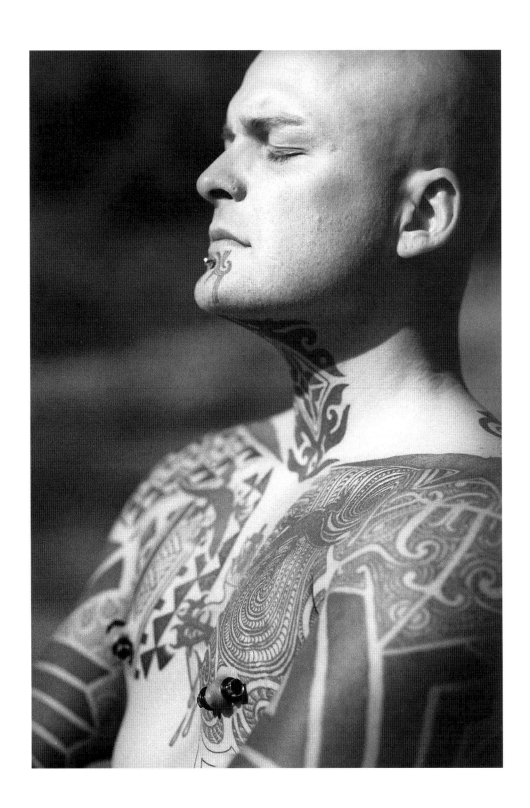

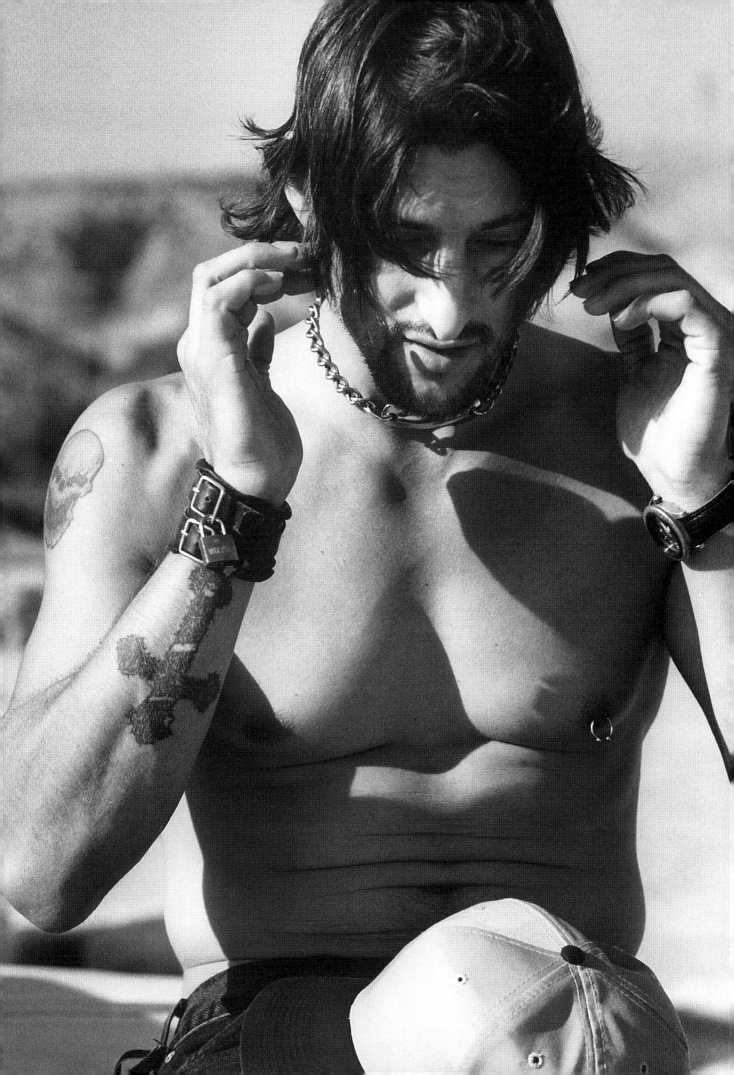

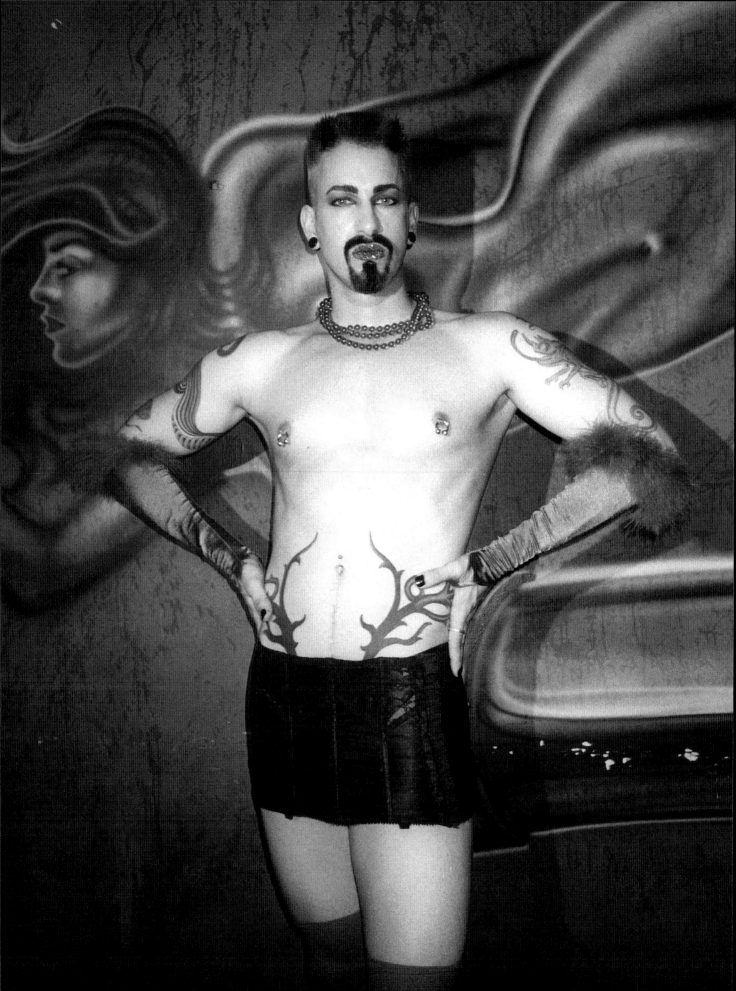

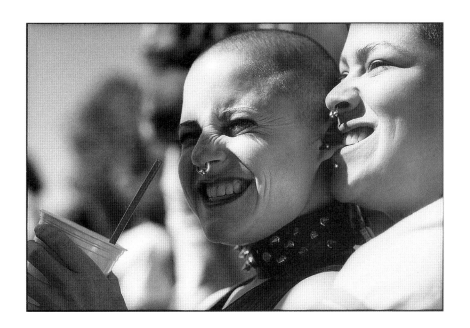

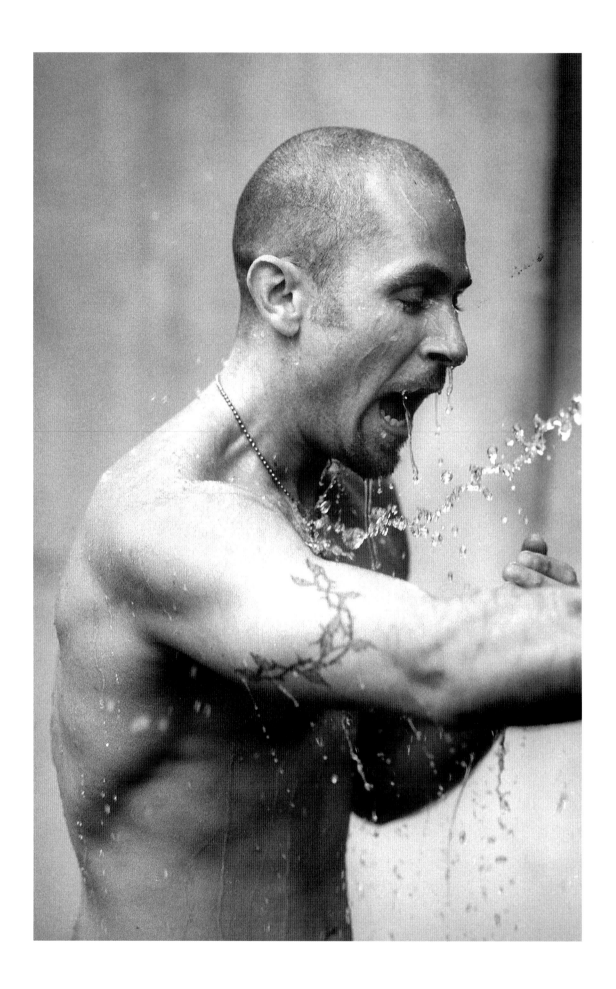

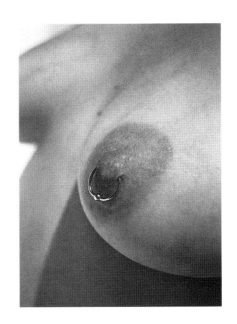

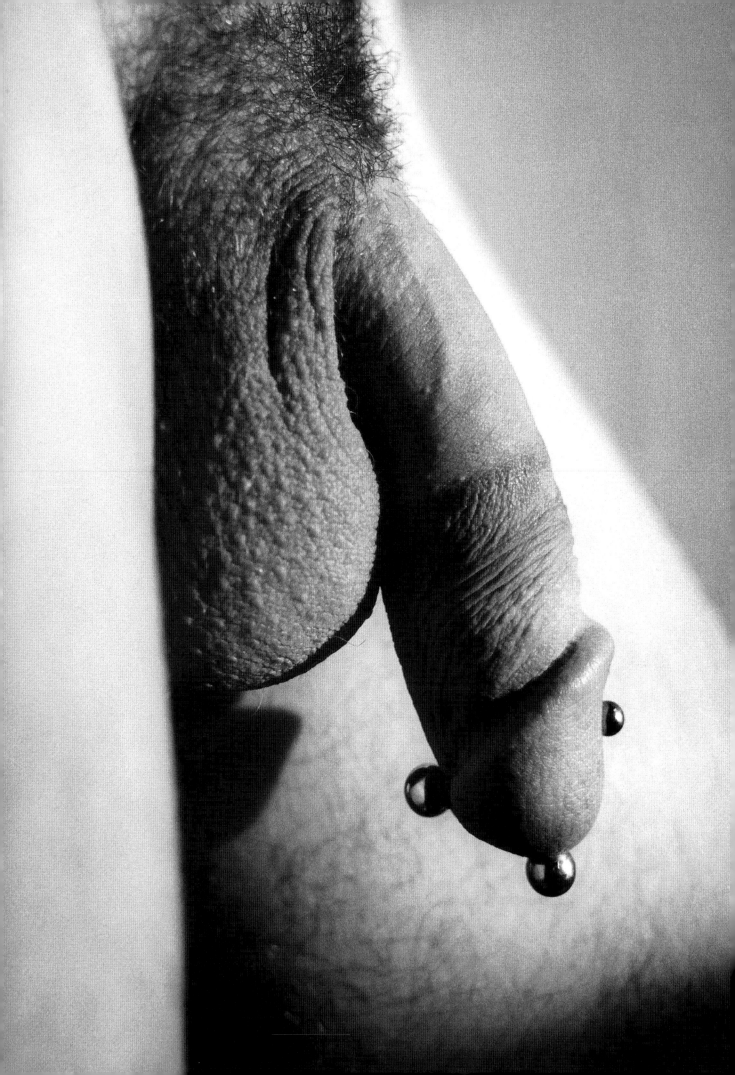

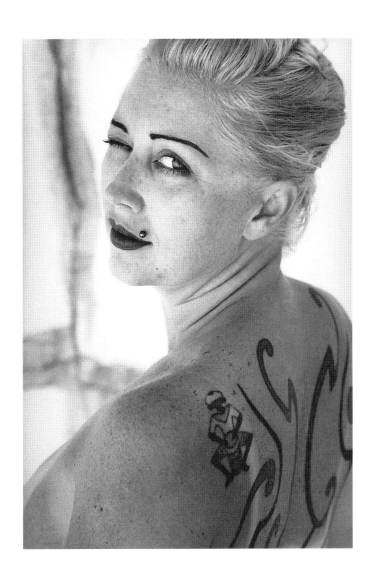

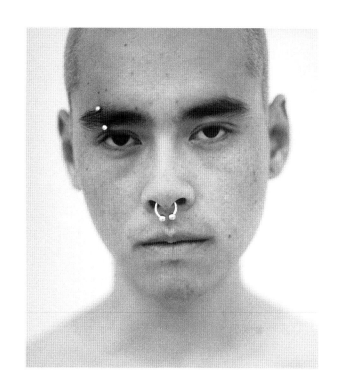

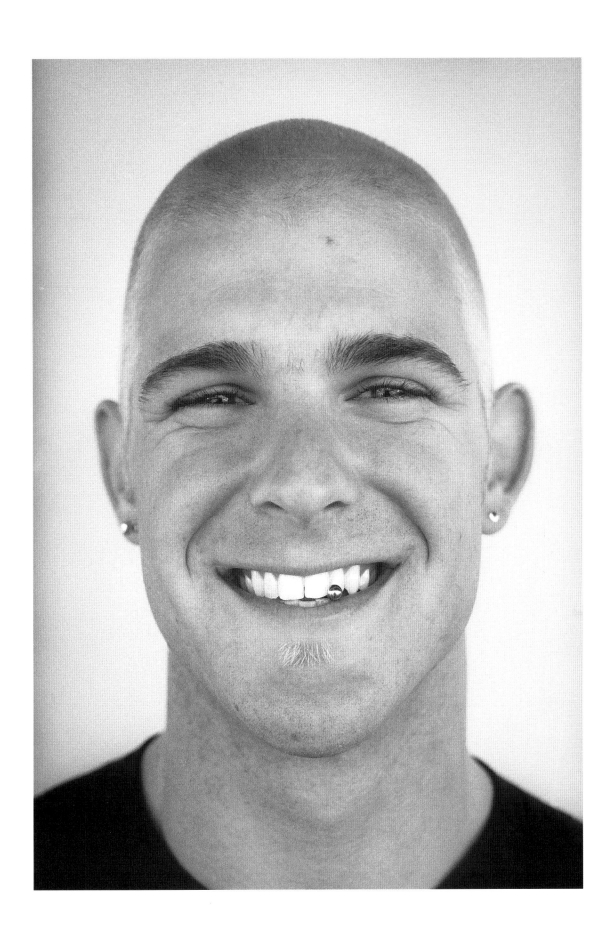

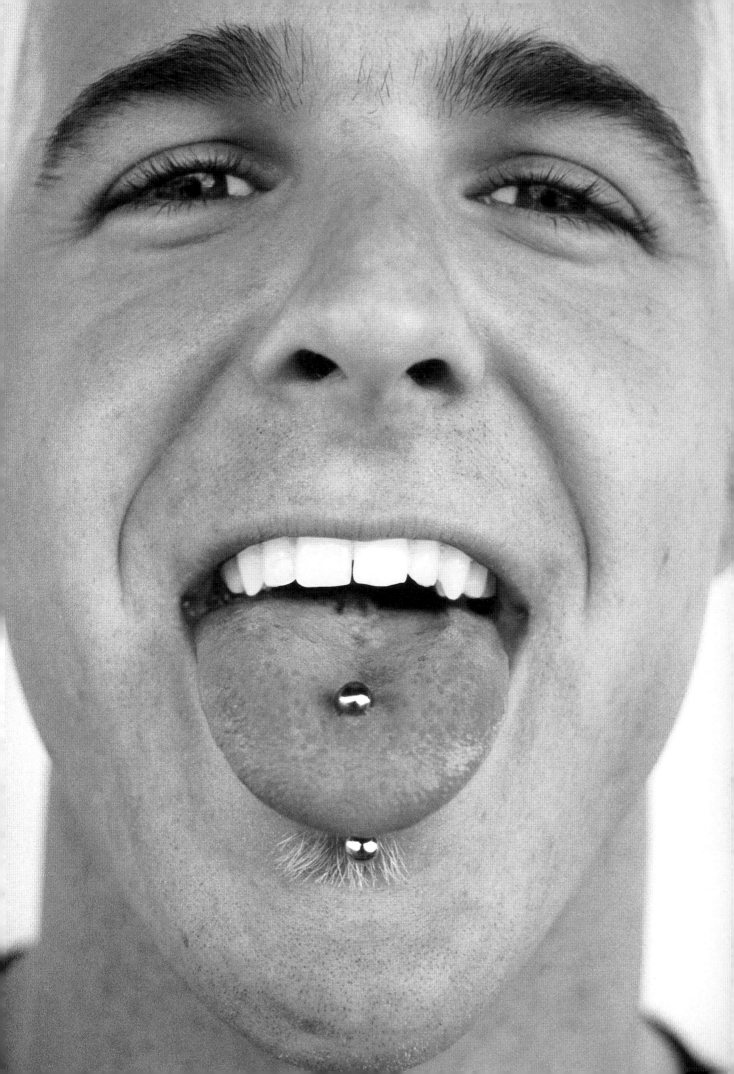

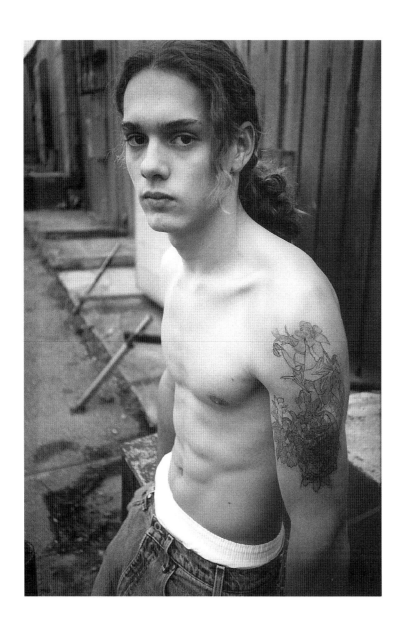

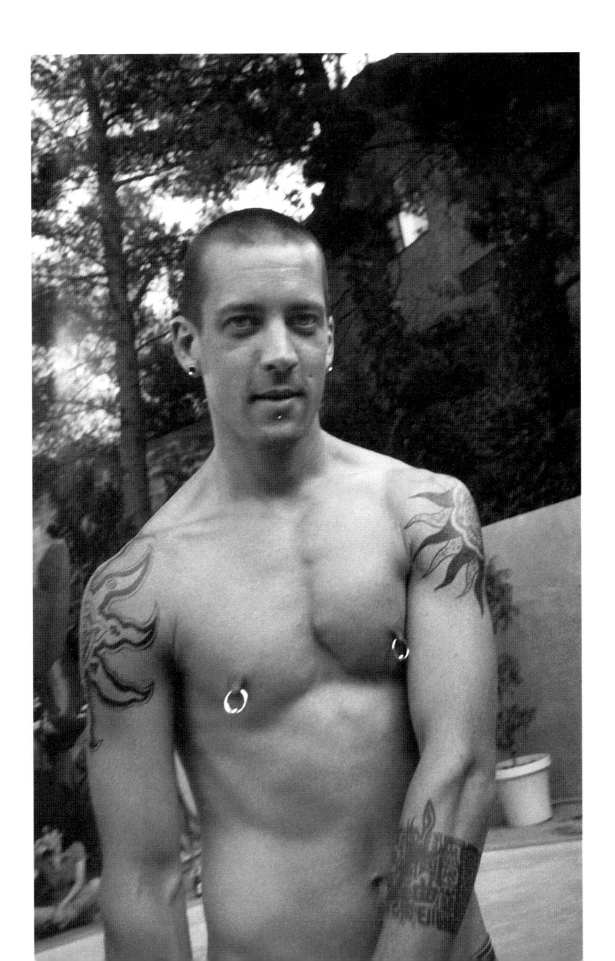

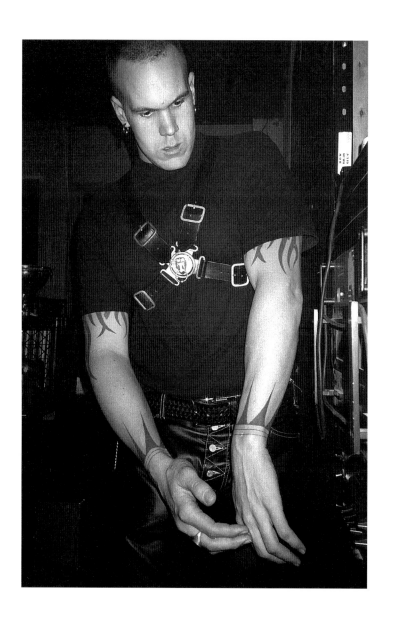

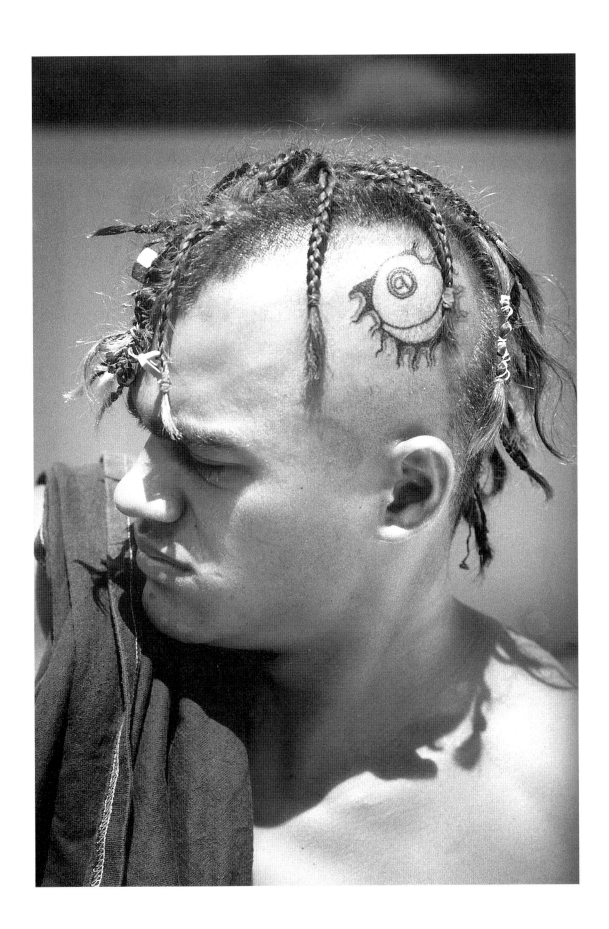

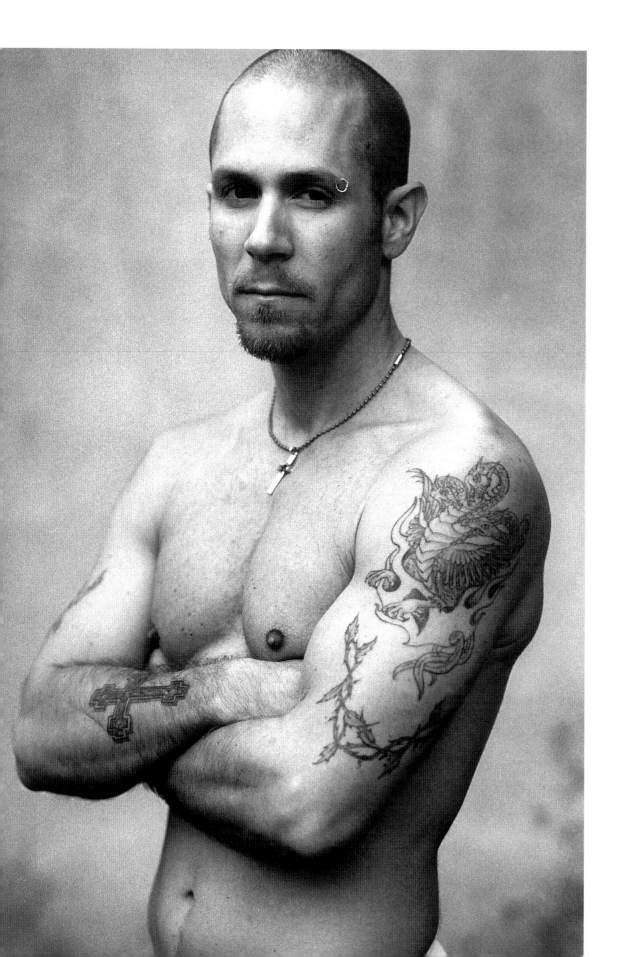

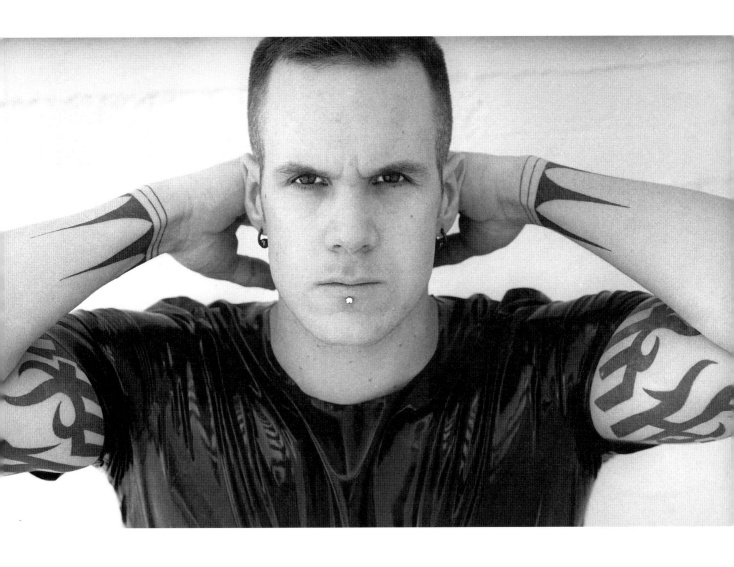

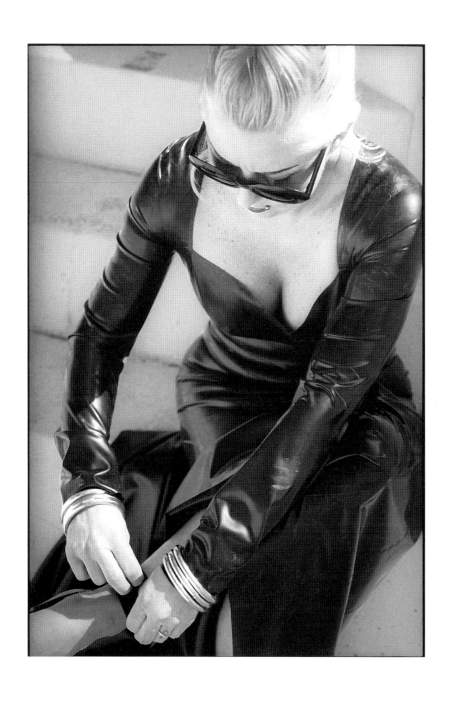

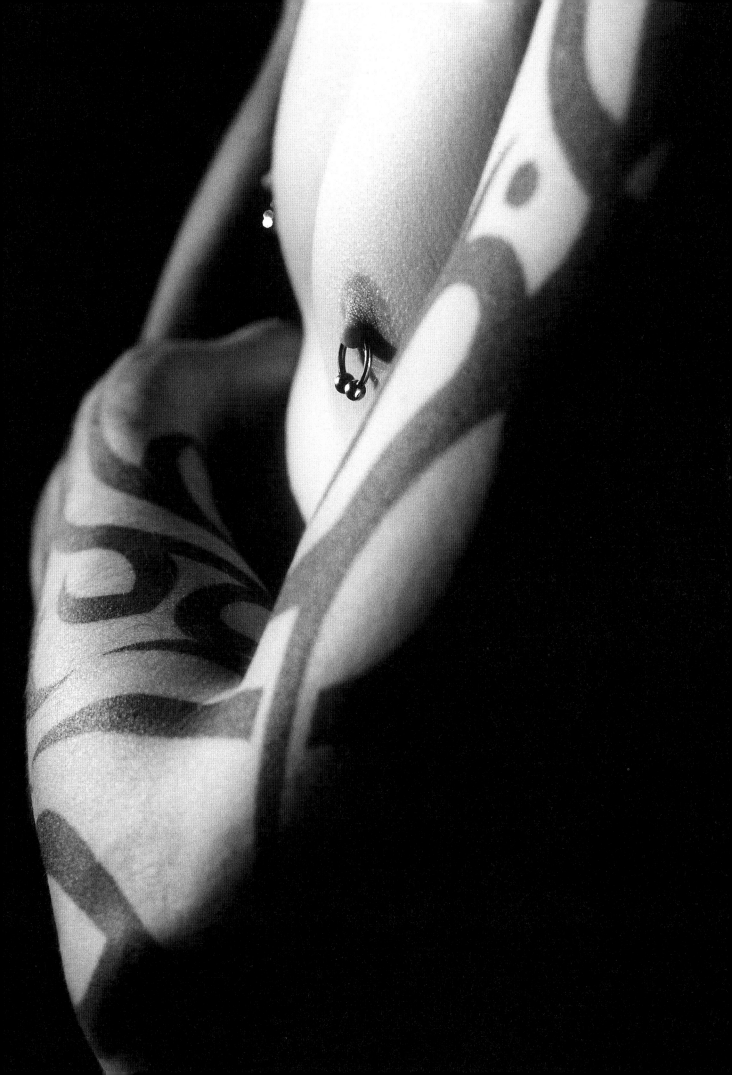

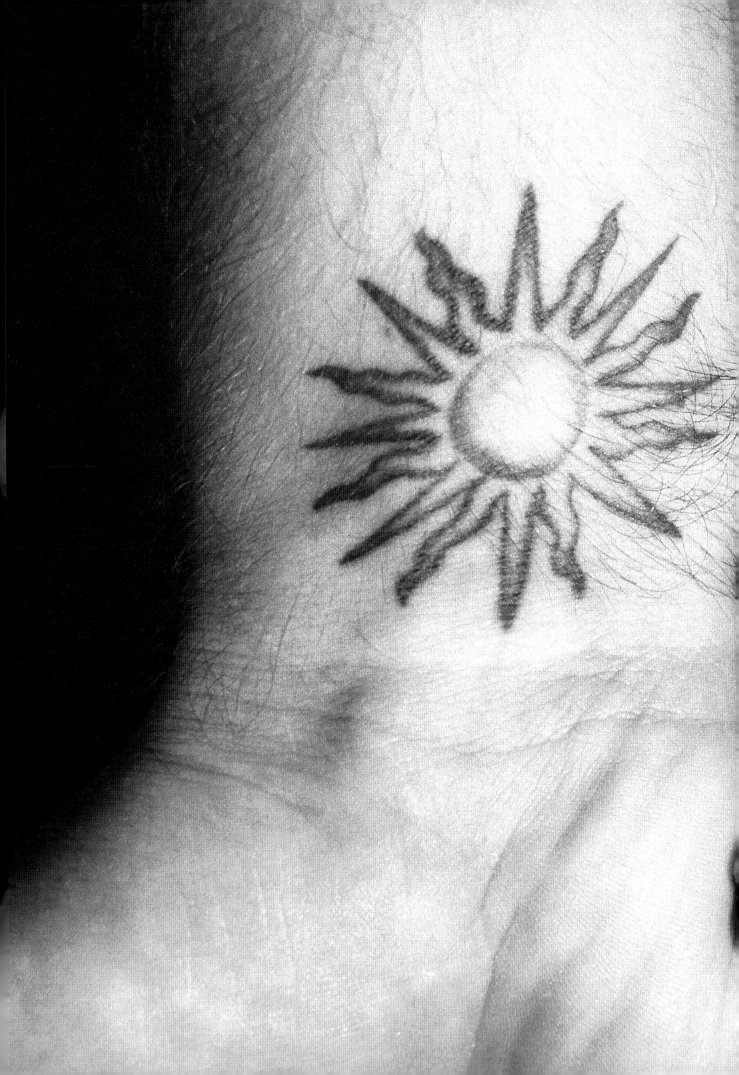

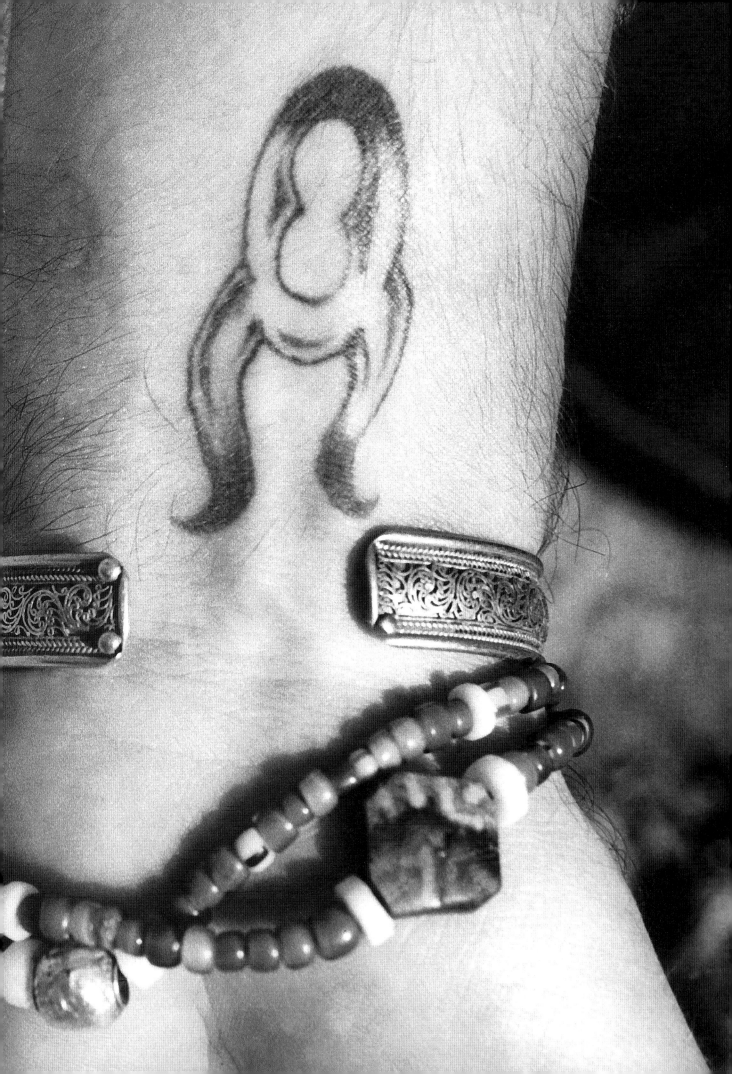

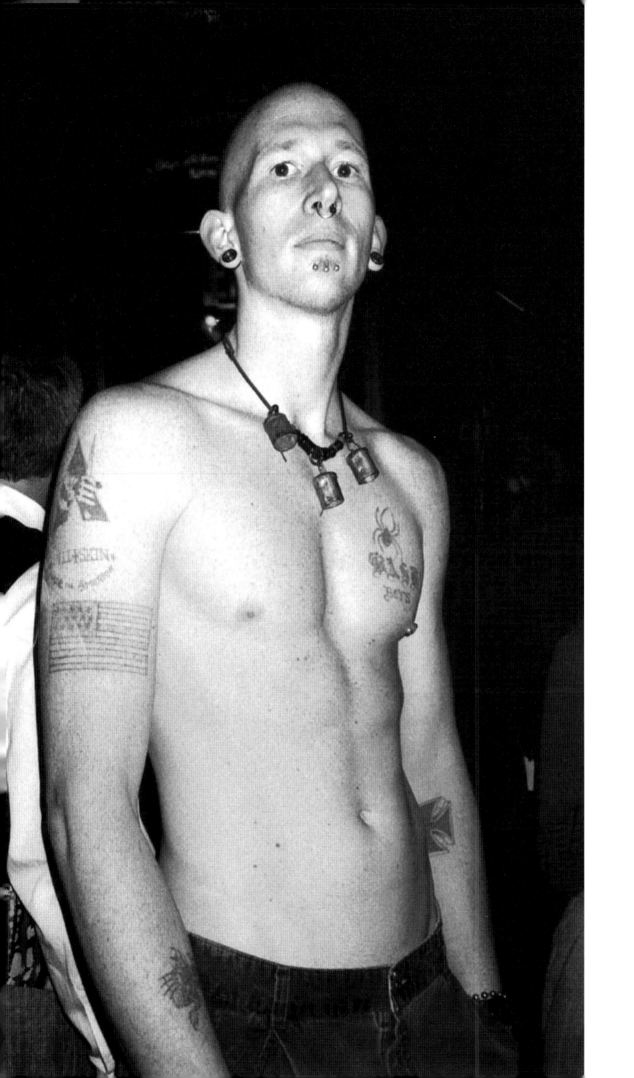

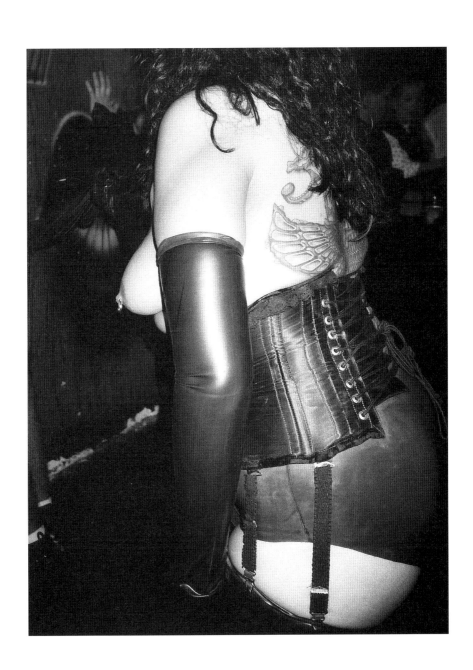

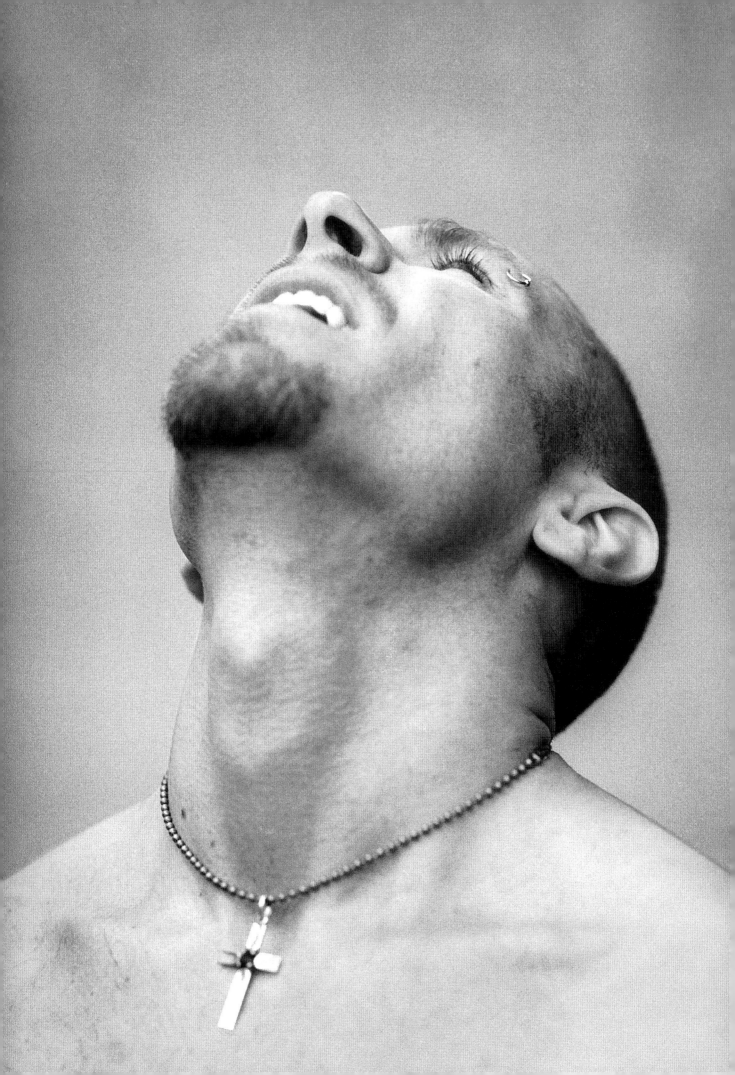

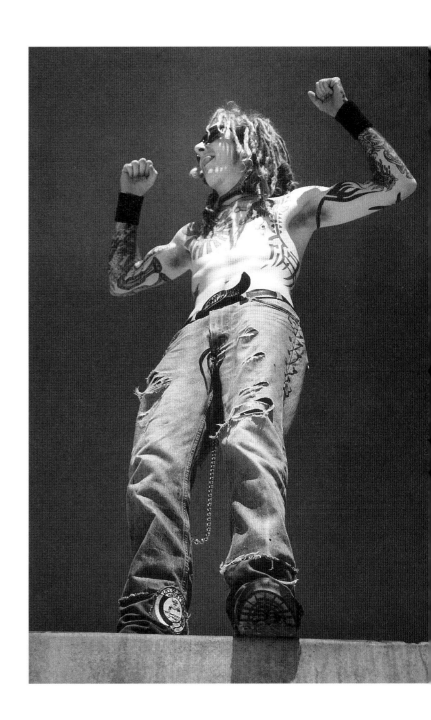

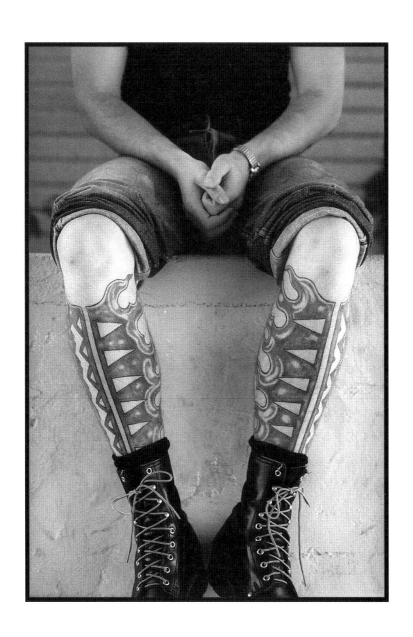

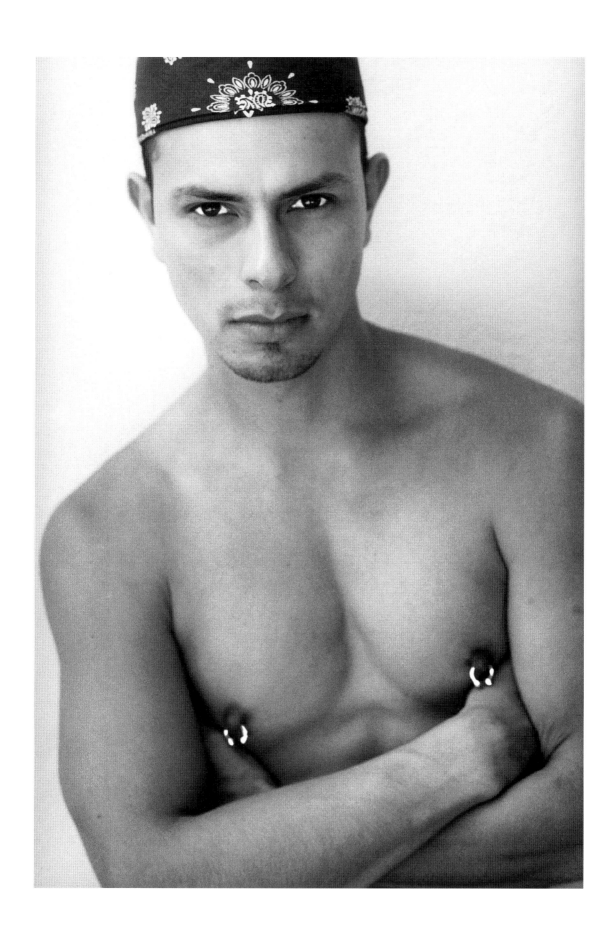

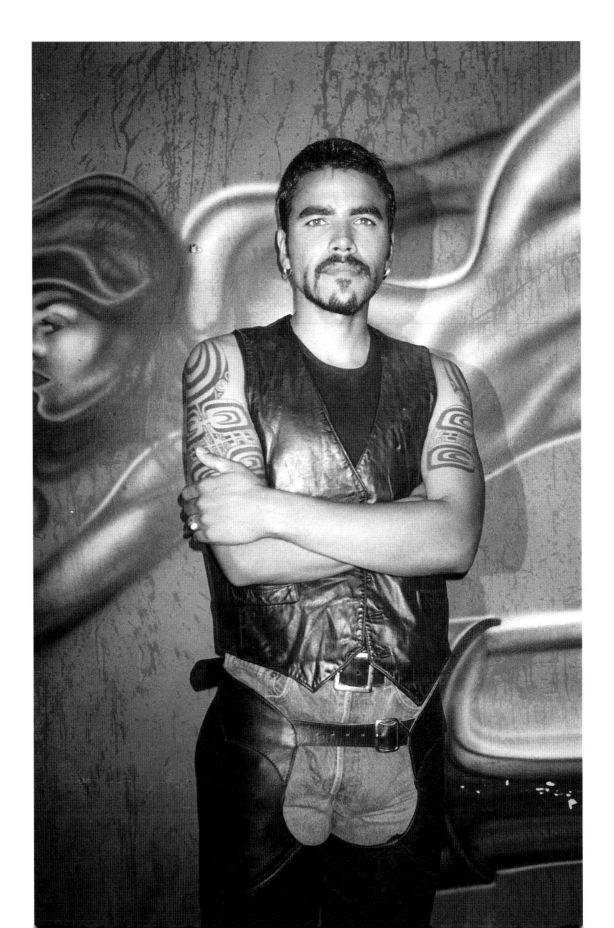

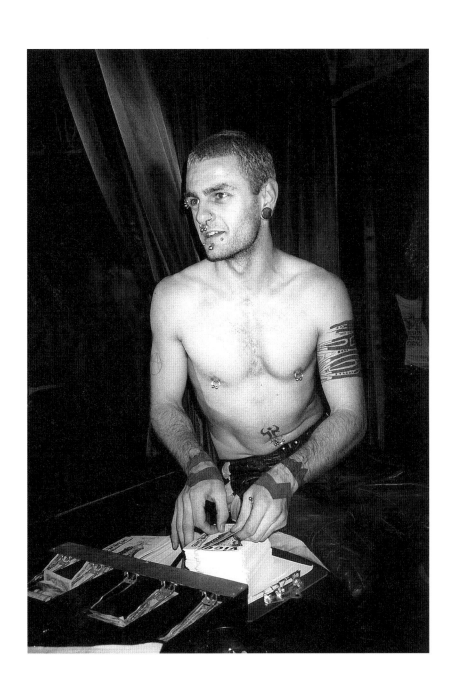

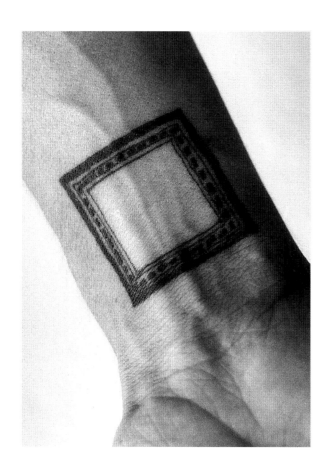

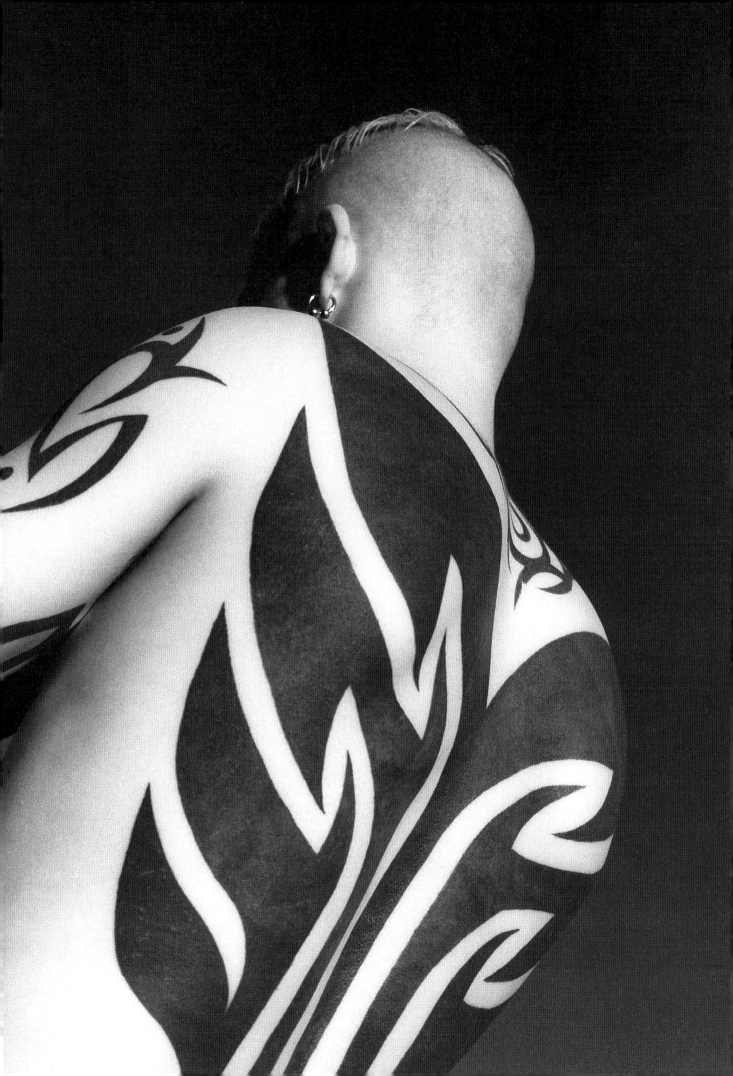

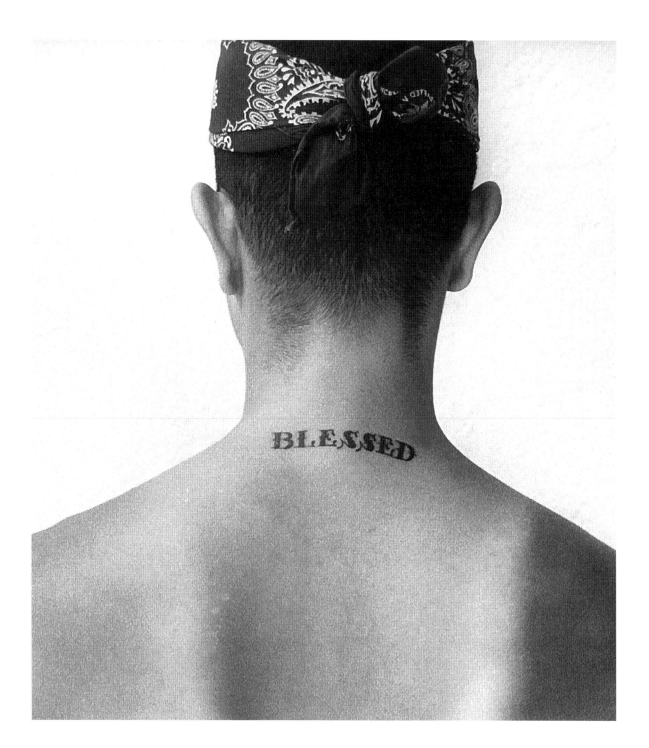

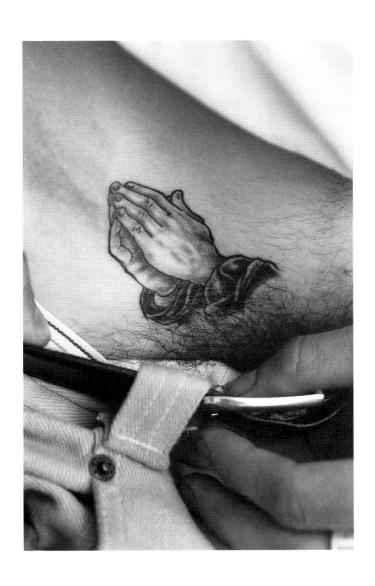

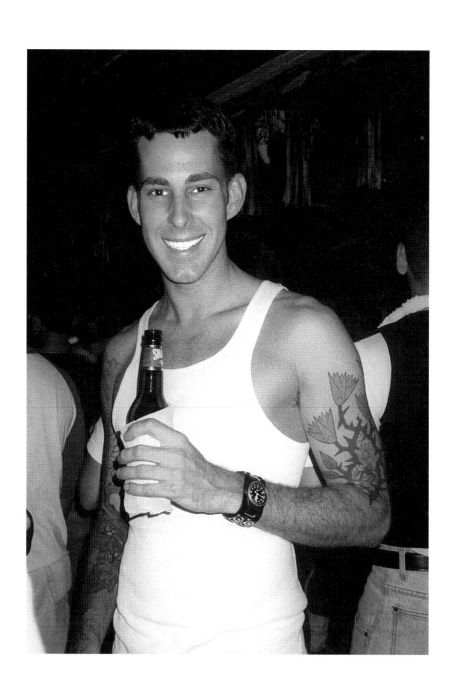

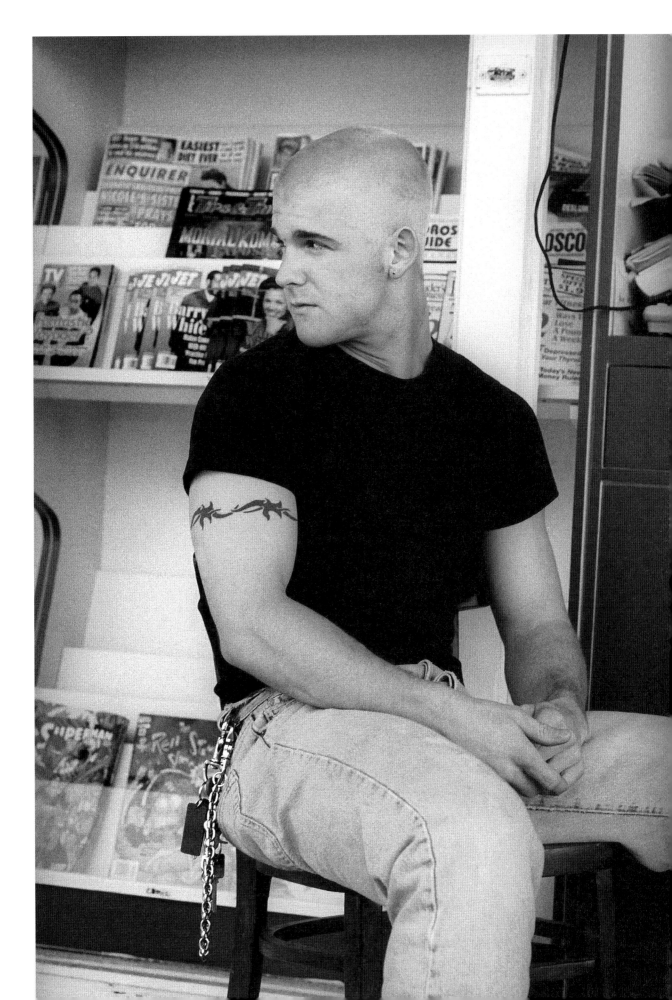

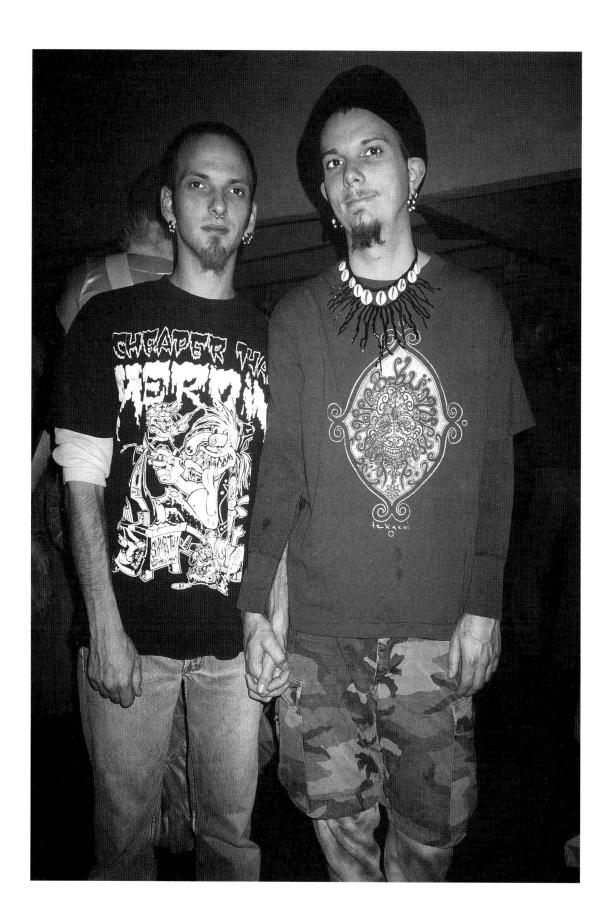

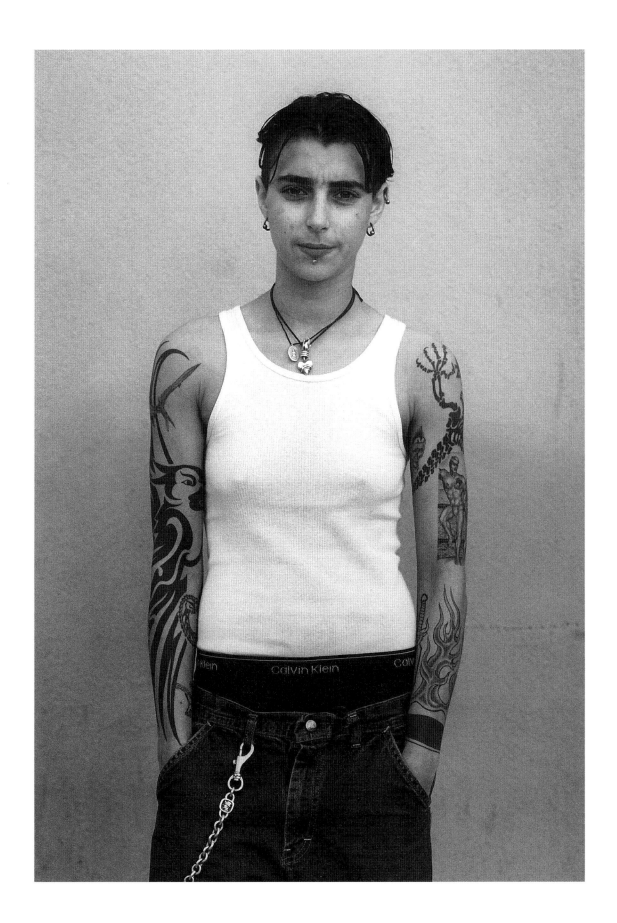

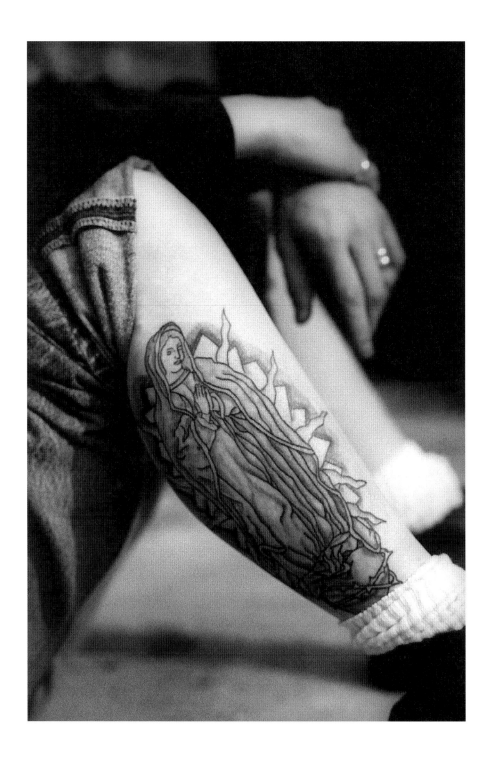

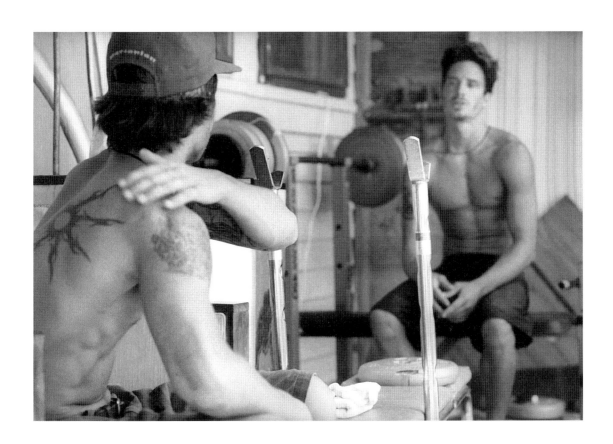

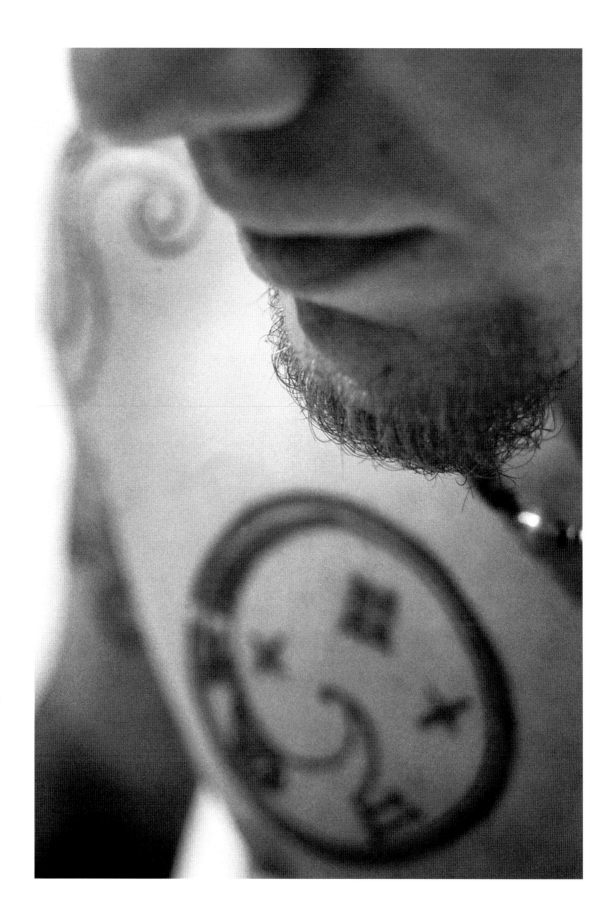

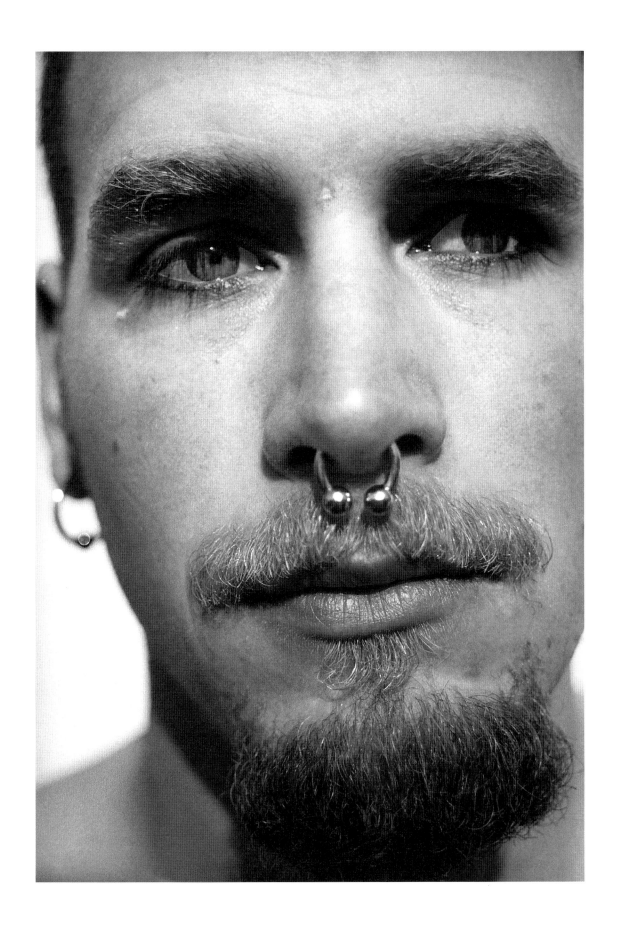

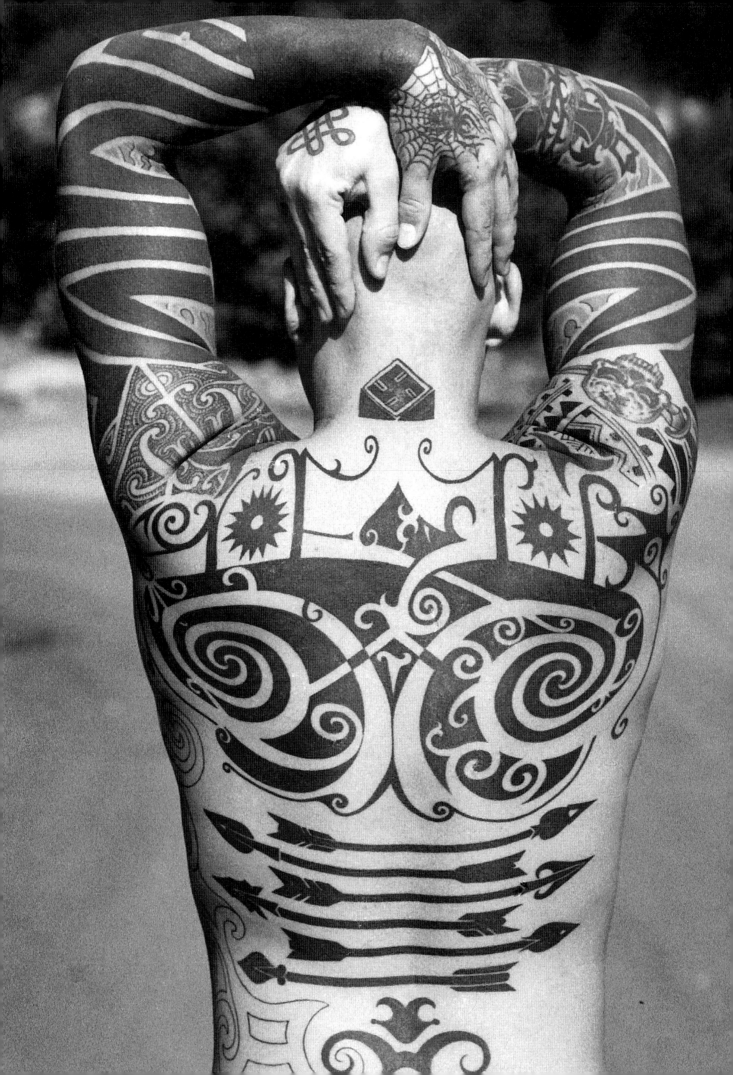

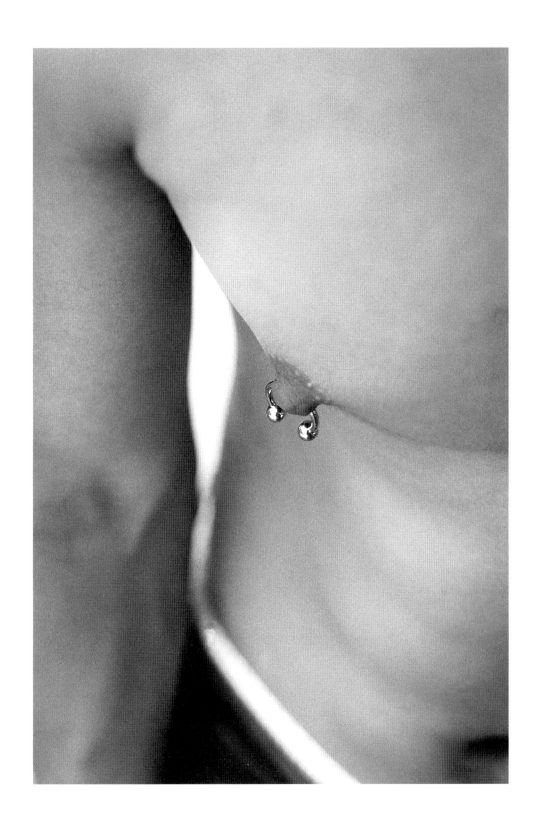

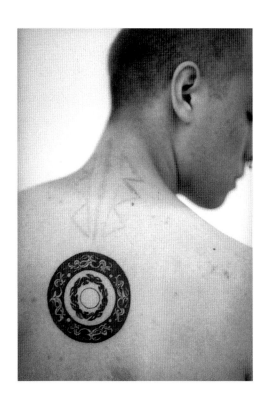

Published by Universe Publishing, A Division of Rizzoli
International Publications, Inc., 300 Park Avenue South,
New York, NY 10010 and Jackwerth Verlag, Cologne, Germany.

Distributed to the U.S. trade by St. Martin's Press, New York
Distributed in Canada by McClelland & Stewart

Edited by Bernd Fechner, Cologne
Design by Groothuis+Malsy/Wendt, Bremen
Printed by Wagner, Nördlingen

ISBN 0-7893-0096-6
Library of Congress Catalog Card Number: 97-60207

Printed in Germany